TAROT

T&J

Published by TAJ Books International LLC 2014
5501 Kincross Lane
Charlotte, North Carolina, USA
28277

www.tajbooks.com
www.tajminibooks.com

Copyright © 2014 TAJ Books International LLC

All rights reserved. No part of this publication may be reproduced, stored in a retrieval system, or transmitted in any form or by any means, electronic, mechanical, photocopying, recording, or otherwise, without the prior written permission of the Publisher and copyright holders.

All notations of errors or omissions (author inquiries, permissions) concerning the content of this book should be addressed to info@tajbooks.com. The Publisher believes the use of the tarot card images at the size depicted qualifes as fair use under United States copyright law.

ISBN 978-1-84406-338-3
978-1-62732-015-3 Paperback

Printed in China

1 2 3 4 5 18 17 16 15 14

TAROT CARDS

ISABELLA ALSTON & KATHRYN DIXON

INTRODUCTION

The first-known documented playing cards in Europe are believed to have originated in the 14th century, most likely in Egypt. It remains a mystery whether tarot cards came before or after the invention of playing cards although it is generally presumed that the tarot was developed second. The earliest Middle Eastern playing cards consisted of four suits: Swords, Staves, Cups, and Coins. This organization shows a clear connection between the two types of cards—playing cards and tarot cards. Tarot decks generally refer, however, to the Staves suit as Wands or Clubs and the Coins suit as Pentacles.

Many historians believe the tarot is directly connected to both the Ancient Mysteries and the Egyptian Initiations, the latter likely being connected to the ancient Hermetic (magical) use of symbolism. In the 14th and 15th centuries, a great amount of cultural exchange was occurring between the Middle East and Europe, particularly in Spain with the Moorish invasion. In more modern times, the tarot has often been associated with gypsies, and the earliest gypsies, those who lived in Europe during the medieval years, were associated with peoples of mixed ancestry who lived in Spain. Thus, the gypsy connection appears to have some historical justification. The French 19th-century magician and occultist Eliphas Levi incorporated tarot cards into his magical system, which cemented the connection between the tarot and magic.

The very first official tarot deck was created in Milan, Italy, between 1428 and 1447. The set depicted both the Visconti and Sforza families, at the time the ruling families of this region of Italy. Historians are certain of this deck's existence due to a court record from Ferrara, Italy, in 1442 that references the deck. Some cards belonging to the original Visconti-Sforza deck remain today. The very popular deck has been replicated in numerous additions over the years. The original Visconti-Sforza deck was not only beautiful in design, it was produced using precious metals such as gold, which only adds to the value of the remains of the original deck.

The Visconti-Sforza deck differed from playing card decks because, in addition to the four card suits, what we now call the major arcana was added to the deck. The four suits of cards became the minor arcana. The major arcana is the primary feature that sets the tarot apart from decks of playing cards. Each card in the major arcana represents a specific allegorical story, each one in turn meant to represent a specific part of life's journey. In the 15th century in northern Italy, the tarot deck was referred to as *carte de trionfi*, which translates as "triumph cards." A derivative or bastardization of "triumph" gave us today's

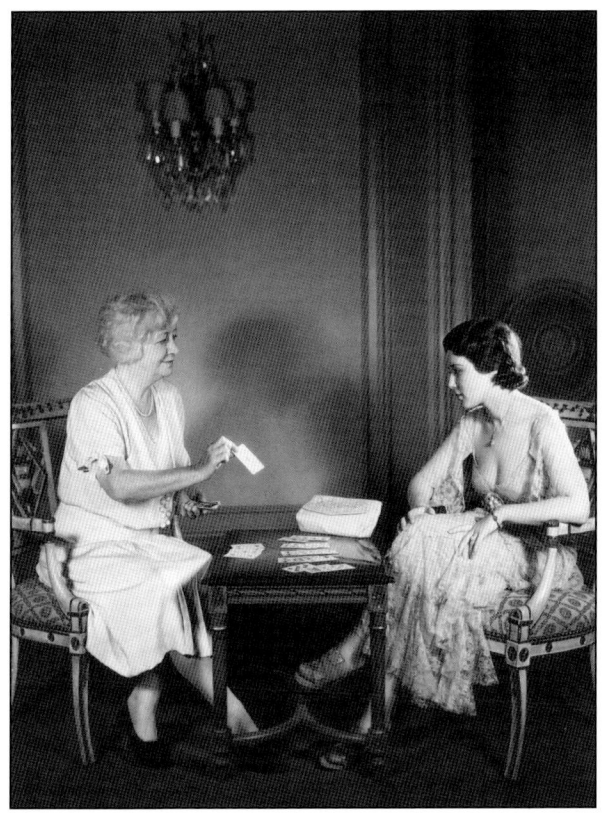

A young woman having her cards read. The reader is using a regular playing card deck, however, not a brightly illustrated deck of the tarot.

English word "trump" card as referred to in modern card games and the major arcana cards.

As the tarot gained popularity, numerous variations were created, often using the local noble families as subjects, as did the Visconti-Sforza deck. Until the origin of the printing press, tarot decks were almost always hand-painted, making them very expensive, accessible only to the upper classes. Once the printing press allowed for mass production, however, the popularity and use of the tarot spread widely throughout all walks of society.

The earliest tarot was still only used as a game. The tarot's use in fortune telling did not come about until the late 1700s. Nevertheless, whether due to a reputed gambling connection as pure playing cards or a mystical use as in divining the future, the tarot has a long history of being viewed by the Christian church as representing evil.

From a modern perspective, the tarot has numerous uses, most of which have the purpose of encouraging self-knowledge and reflection. The beauty and lyricism of hundreds, and even thousands, of tarot decks illustrated throughout the last 600 years, as well as those currently in circulation and those yet to be designed and published, make them a unique art form. This book celebrates that art form.

The minor arcana consists of 56 cards. The major arcana consists of 22. In total, 78 cards make the deck. Both arcanas have significance in the divinatory art of numerology. The number of cards, 56, in the minor arcana equates to the master number 11 (5 + 6). Likewise, the master number 22 is the total number of cards in the major arcana. Numerology plays a key role in the meaning and interpretation of the tarot. Delving further into the numerological meaning of the tarot, the deck can be divided into three categories: the first is 21 numbered cards; the second is the single Fool card, which is ascribed the number 0; and the last is the 56 cards that make up the four suits of the minor arcana. The Fool links the two parts of the deck together by representing both the beginning and the end.

Lending even greater meaning to the trinity of the tarot, it can be viewed as representing the relationship between and among God, Man, and the Universe, or in other words, the relationship between and among the world of intangible consciousness, the world of tangible ideas, and the literalness of the physical and material world. This triad can be further interpreted as a metaphorical representation of the human soul as every individual encompasses each of the three elements, regardless of the individual's awareness of this reality. The complexity of the tarot therefore suggests its use is not as trivial as many

have made it out to be; instead, the tarot offers a means of communicating between the physical and the spiritual worlds, both of which humans incorporate yet may not always understand.

The tarot is ultimately an amalgamation of myriads of esoteric beliefs built upon over the centuries. The Hermetic sciences include Kabbalah (Judaic mysticism), Alchemy, Astrology, and Magic. These "sciences" all seek to investigate the true nature of man and his relationship to the noumenal (spiritual) world as well as to the phenomenal world (i.e., what we can physically and visibly experience) through the analysis and divination of different mediums.

Astrology, for example, uses the galaxy and constellations, whereas Alchemy relies on the metals and elements. Each of these sciences, arts, or practices (however characterized) shares the belief that the sources of insight and enlightenment to which it uniquely subscribes hold the ultimate "truth" for mankind. This truth is hidden to the uninitiated. Each aims to "initiate" the uninitiated by shedding light on the ultimate truth about life and death and the implications for the soul of Man, both individually and as a single whole, in relationship to God and the universe.

For most people, the tarot is a medium through which the intuitive sense can be awakened. Everyone has the innate power of intuition, but for some this sixth sense may not be well developed. Meditation also enhances the intuitive sense and tends to heighten the ability to read the tarot.

Studying the tarot takes time. Each card on its own provides a wealth of information in the form of symbols, numbers, and astrological references, and there is no single correct interpretation of any card. Neither is there a single correct reading of a spread, which requires not only interpreting the meaning of the individual cards, but also the meaning of the entirety of the spread and how each card is read in combination with the rest. This is why increasing and improving intuitive power is a key to unlocking the meaning of the tarot. Keeping a journal of tarot readings is a good way to preserve and process past readings.

The Rider-Waite deck is the best-known deck in the English-speaking world. The images on the cards are very straightforward in terms of the symbols and archetypes used. The deck was originally published in 1910 by the London publisher William Rider & Son, with the art contracted from the artist Pamela Coleman Smith. Soon thereafter, a guide to the tarot written by A.E. Waite was included with the deck, hence, the deck's name. It is sometimes referred to as the Rider-Smith-Waite deck.

Cards from the Rider-Waite deck have

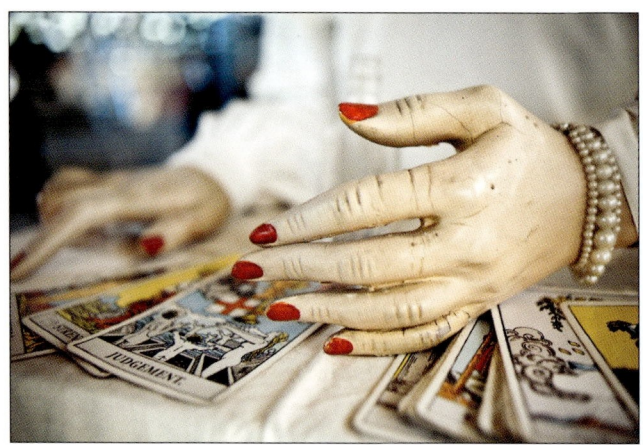

appeared in numerous unexpected places, such as in the video backdrop for the song "Hollywood" in Madonna's 2004 *Re-Invention World Tour* and in the Bond movie "Live and Let Die."

So many different tarot decks exist however, with each expressing the artist's unique vision, that choosing the deck or decks that speak to the reader should not be a difficult task. At least one tarot reader we know lets the person she is reading for choose the one deck out of about 50 in her collection that most appeals to them in order to enhance and improve the reading.

Twenty-two cards compose the major arcana. The Rider-Waite deck was groundbreaking in that it moved away from the Christian symbolism that its predecessors embraced. For example, the Pope became the Hierophant and the Papess became the High Priestess. The cards in the major arcana are typically the Fool, Magician, High Priestess, Empress, Emperor, Heirophant, Lovers, Chariot, Strength, Hermit, Wheel of Fortune, Justice, Hanged Man, Death, Temperance, Devil, Tower, Star, Moon, Sun, Judgement, and World. Other decks, both pre and post the Rider-Waite deck, may have different names for some or even all of the trump cards.

The numerological association of the cards goes from 0 for the Fool through 22 for the World. The four suits in the minor arcana in the Rider-Waite deck are Wands, Pentacles, Cups, and Swords.

RIDER-WAITE MAJOR ARCANA

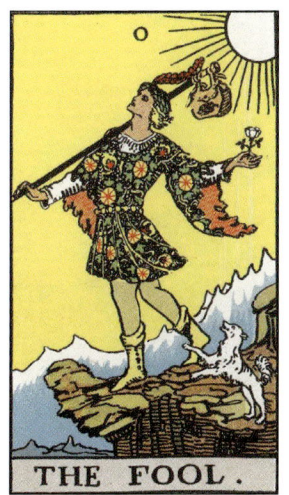
THE FOOL.

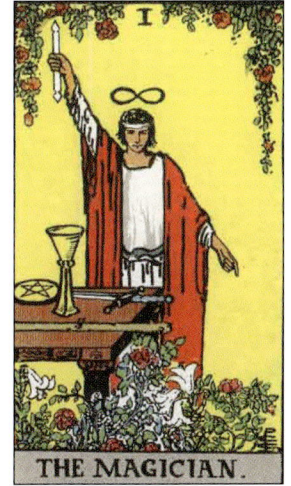
THE MAGICIAN.

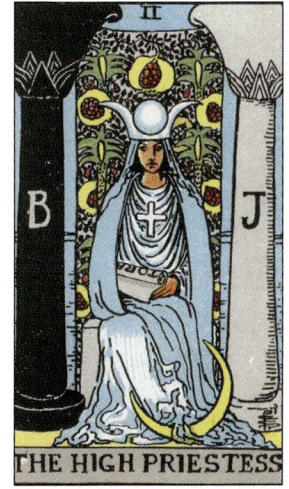
THE HIGH PRIESTESS

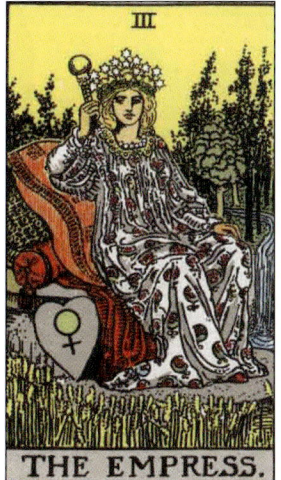
THE EMPRESS.

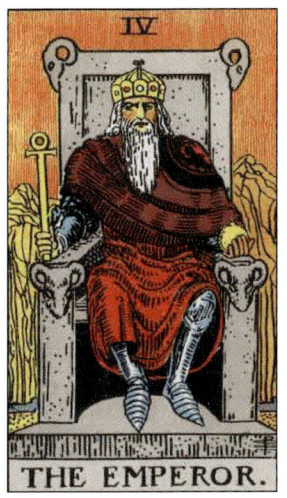
THE EMPEROR.

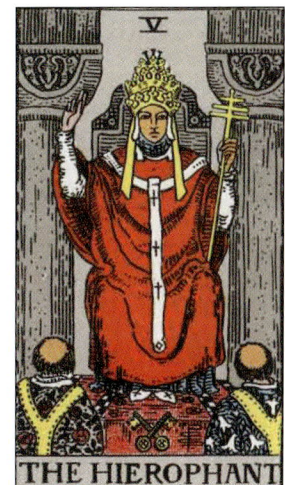
THE HIEROPHANT

RIDER-WAITE MAJOR ARCANA

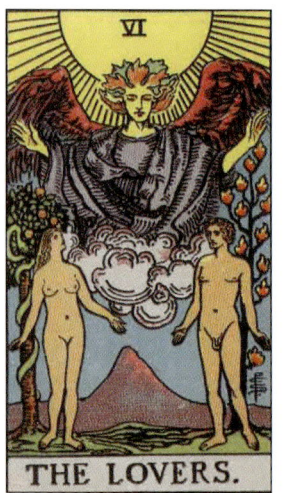
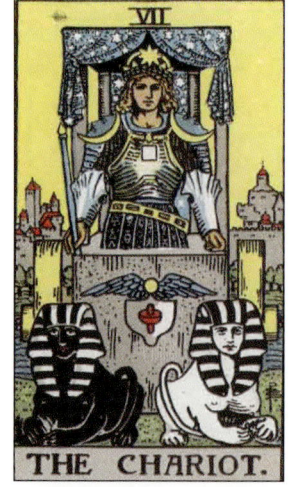
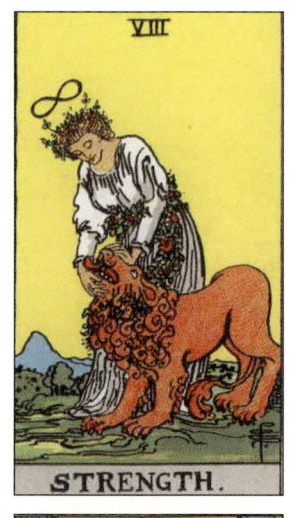
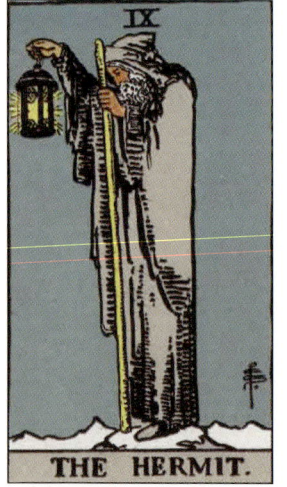
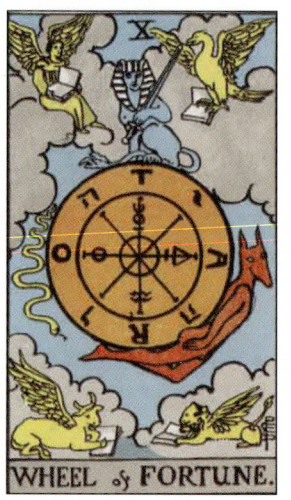
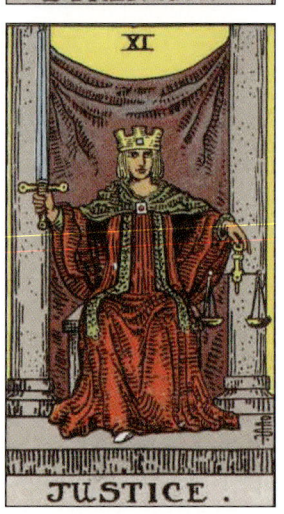

RIDER-WAITE MAJOR ARCANA

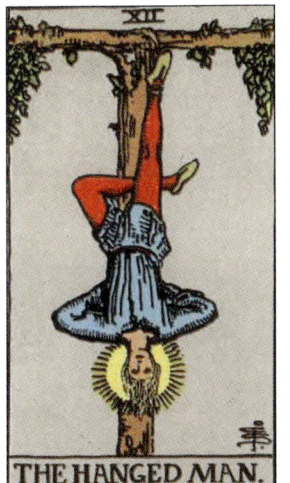
THE HANGED MAN.

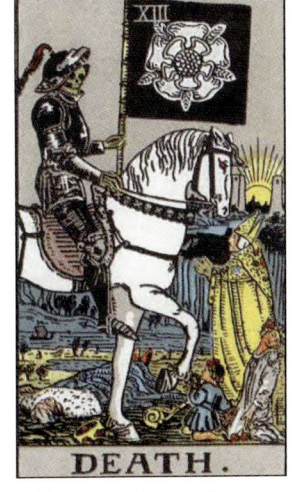
DEATH.

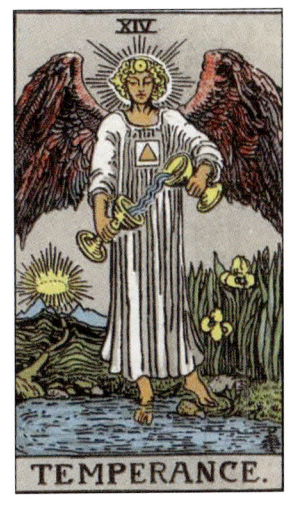
TEMPERANCE.

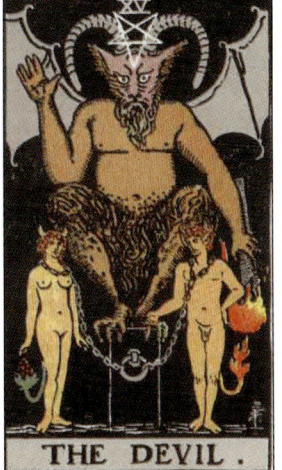
THE DEVIL.

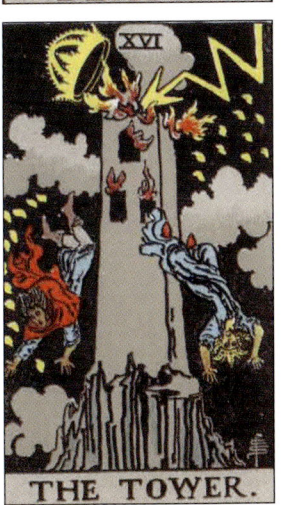
THE TOWER.

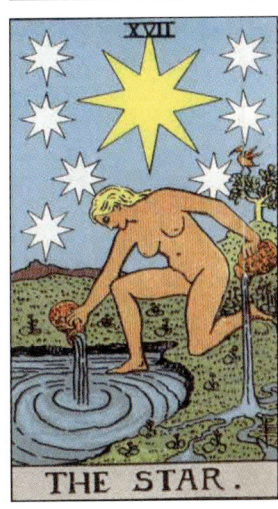
THE STAR.

RIDER-WAITE MAJOR ARCANA

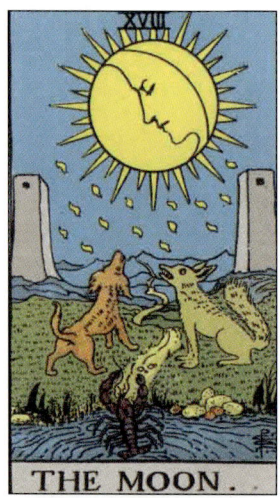

THE MOON.

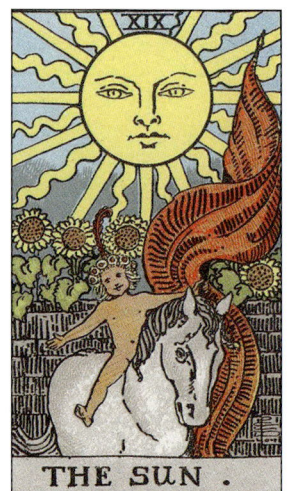

THE SUN.

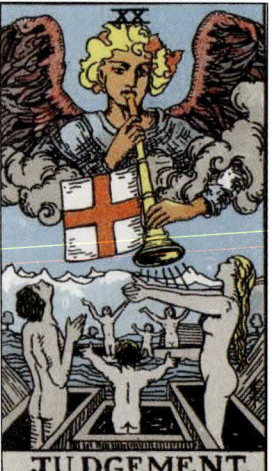

JUDGEMENT.

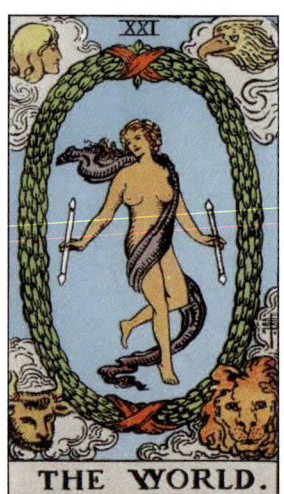

THE WORLD.

RIDER-WAITE MINOR ARCANA KINGS

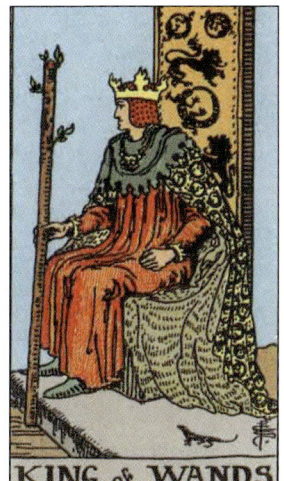

KING of WANDS

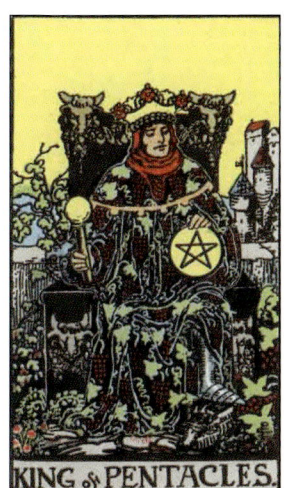

KING of PENTACLES.

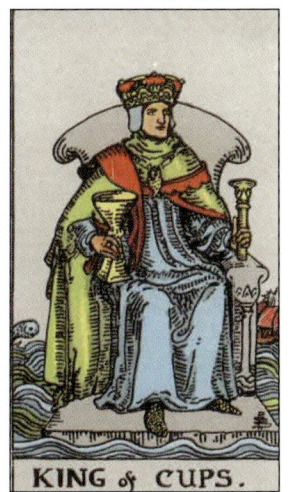

KING of CUPS.

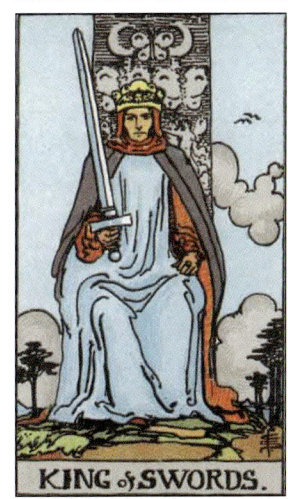

KING of SWORDS.

THE VISCONTI TAROT
15th Century

The Visconti tarot is believed to be the oldest design in the history of the tarot. Fifteen different Visconti decks are known to be in existence today. All are incomplete. One deck is housed at the Yale University Library and was given to the university by Mr. and Mrs. Melbert B. Cary, Jr., who were avid playing card collectors. The deck was commissioned by the Viscontis, a Milanese family, from the fresco artist Bonifacio Bembo. The 67 hand-painted gold and silver tarot cards date from 1428 to 1447. The deck includes 11 trump cards and 6 court cards, including the King, Queen, Male Knight, Female Knight, Male Valet, and Female Valet. Perhaps the inclusion of the Female Knight and Valet were because the deck was meant for a female member of the family. Three cards representing Theological virtues—Faith, Hope, and Charity—are also part of the deck. A second Visconti deck is partially housed at the Pierpont Morgan Library in New York City, the Accademia Carrara in Bergamo, Italy, and in the collection of the Colleoni family of Bergamo. This deck is dated circa 1450 and is also attributed to Bonifacio Bembo. It is believed that the deck was created for Bianca Visconti and her husband, Francesco Sforza. A third deck, composed of 48 cards, is in the collection of the Brera Art Gallery in Milan, Italy. Also created by Bonifacio Bembo between 1442 and 1444 for the Visconti family, the deck was owned by the Milanese family Brambilla. Only two trump cards remain: The Emperor and the Wheel of Fortune.

BRERA-BRAMBILLA DECK

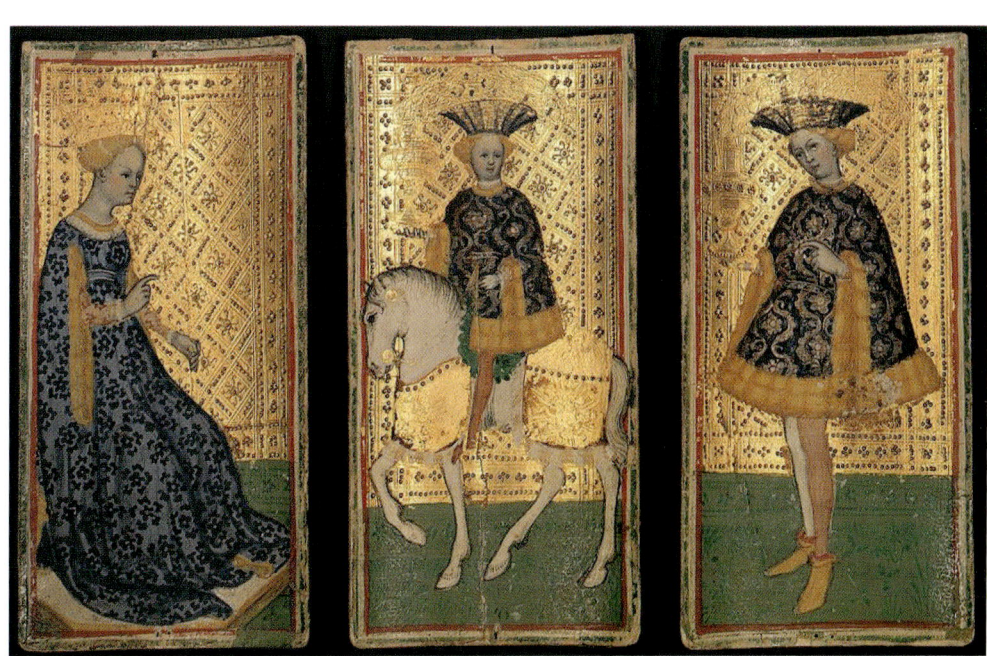

PIERPONT MORGAN-BERGAMO DECK

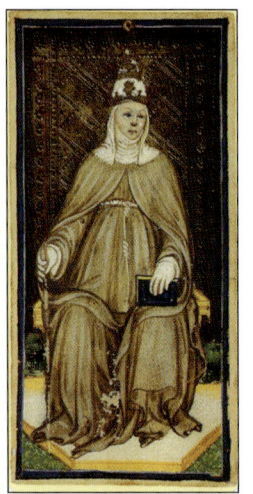
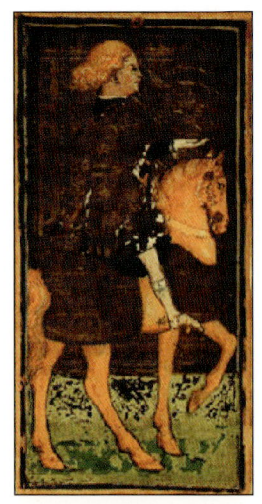
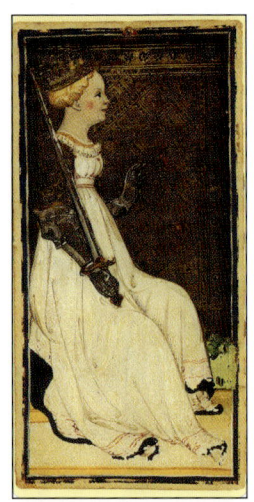
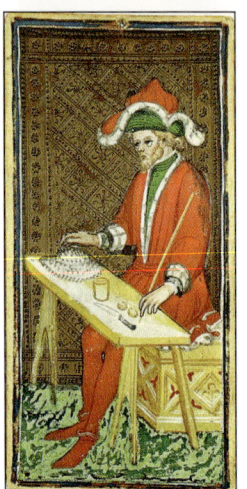
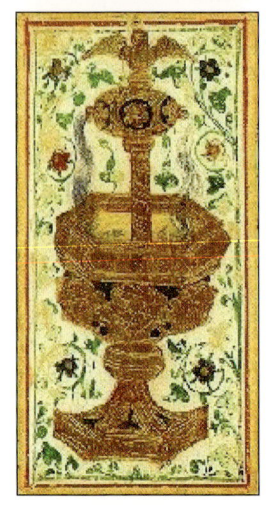
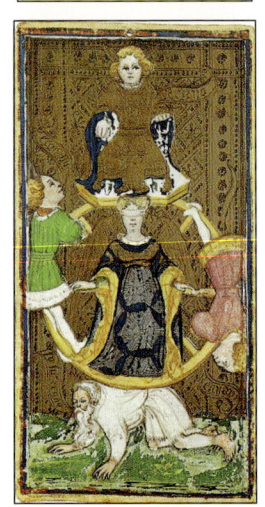

CARY-YALE DECK

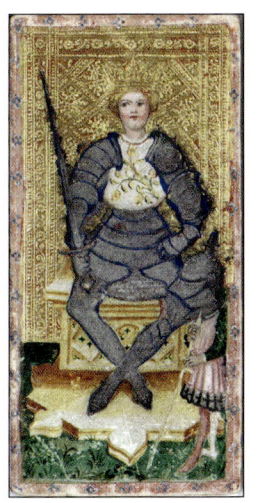
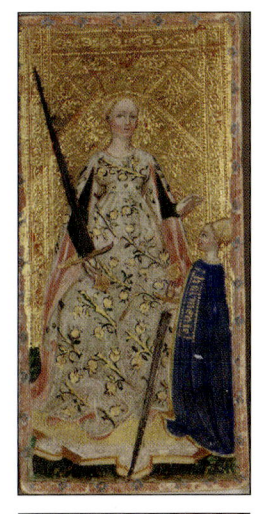
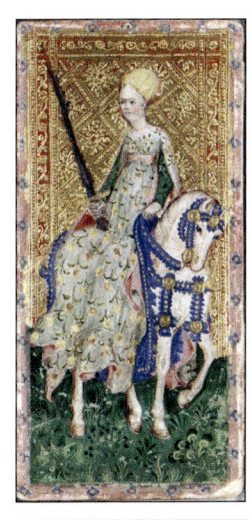
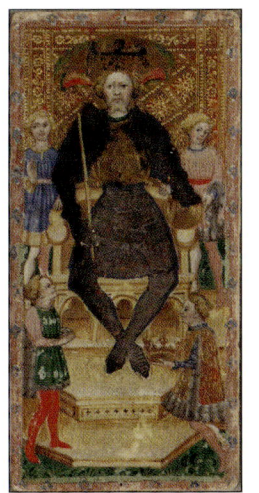
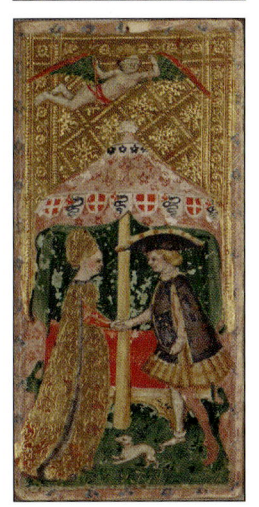
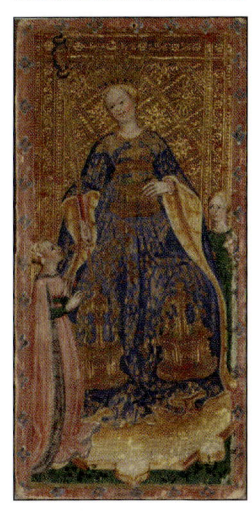

CARY-YALE DECK

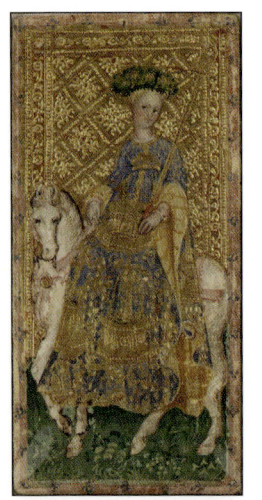
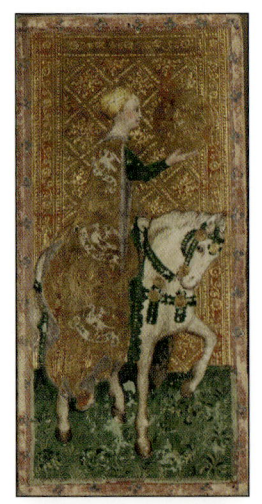
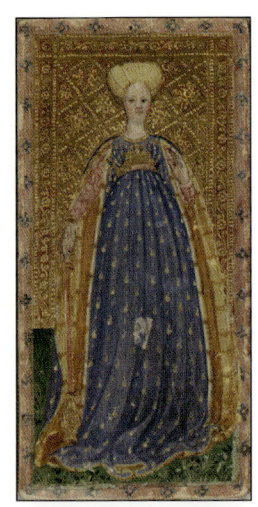
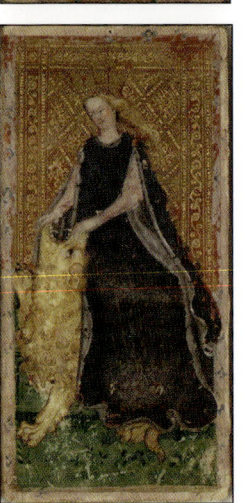
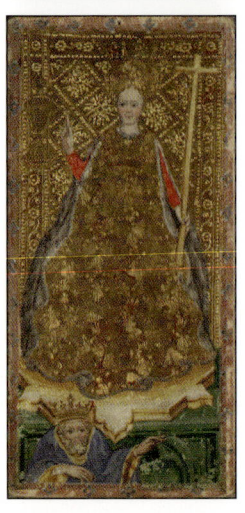
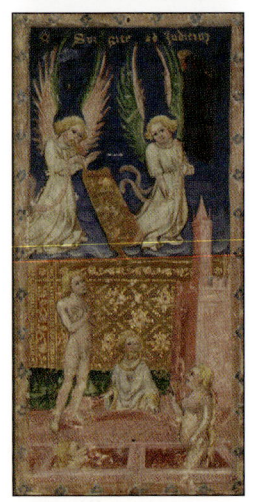

CARY-YALE DECK

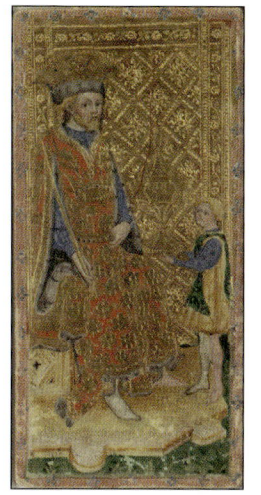
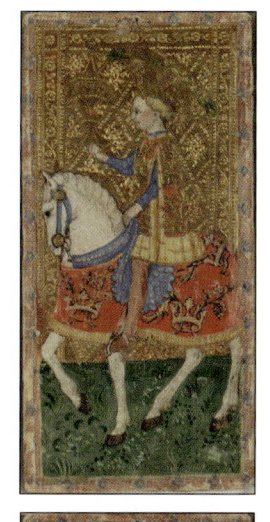
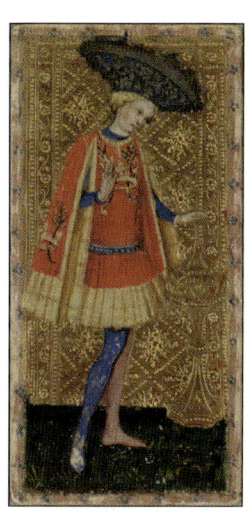
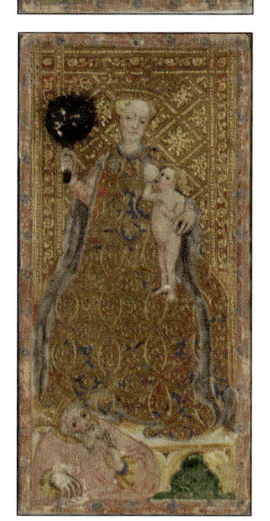
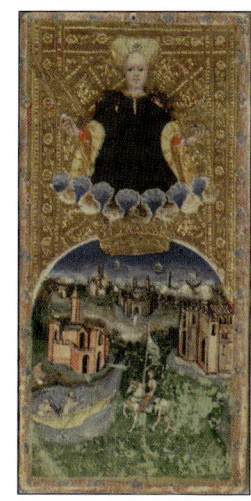

THE SOLA BUSCA TAROT
Late 15th Century

The Sola Busca tarot card deck is named after its former owners, Marquise Busca and Count Sola. The deck was in private hands until it was sold in 2009 to the Italian Ministry of Cultural Heritage and Activities. Today, the Brera Art Gallery in Milan, Italy, houses the Sola Busca tarot deck, which consists of 78 cards. The cards were printed on paper from bulino engravings and illuminated with tempera colors and gold in Venice in 1491. It is the oldest complete tarot deck in the world. The figures on the cards are in very good condition. Although not with absolute certainty, significant research suggests that the owner of the Sola Busca deck and the person responsible for its coloring was Marin Sanudo the Younger, a famous Venetian humanist and historian. Coats of arms that appear throughout the deck are believed to belong to two noble families of Venice: Venier and Sanudo. The monogram "M.S." is also incorporated into the deck's design. The author of the incisions that created the bulino design (the dots and lines engraved into a metal plate) remains anonymous, although scholars now believe that some or all of the engravings may have been produced by Nicola di Maestro Antonio, a painter from Ancona, Italy. The engravings are consistent with his style, which was influenced by the works of the 15th-century artists Marco Zoppo, Giorgio Schiavone, and Carlo Crivelli. The figures of the Sola Busca deck are closely connected to alchemical and hermetic culture. A unique feature of the deck is that the King of Swords is depicted as the deified hero Alexander the Great.

THE SOLA BUSCA TAROT

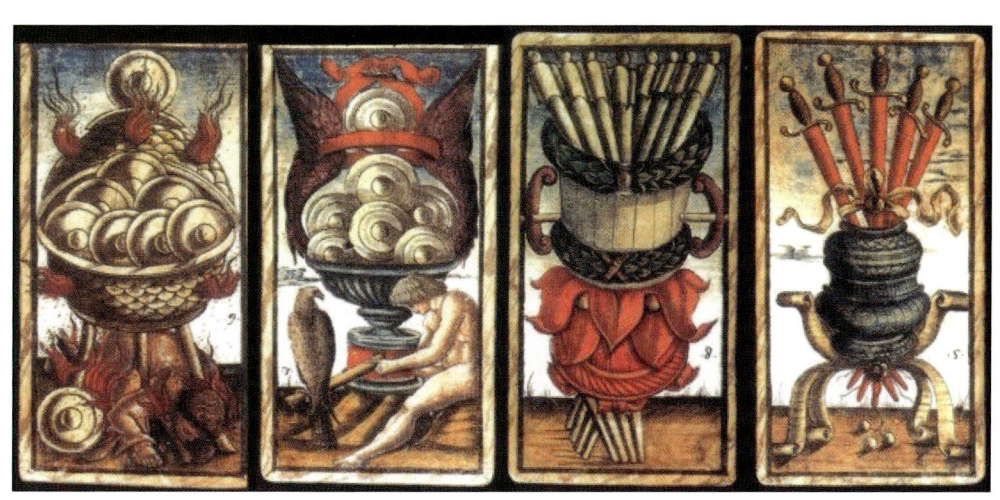

THE TAROT DIT DE CHARLES VI: LA MAISON-DIEU DECK

Late 15th Century

The Tarot dit de Charles VI: La Maison-Dieu is held by the Bibliothèque Nationale de France (National Library of France) in Paris. Only 17 known cards remain in the deck. The artist who rendered them is unknown. Originally created in northern Italy, they were printed with black ink and colored with egg tempera before being stamped with gold and silver leaf.

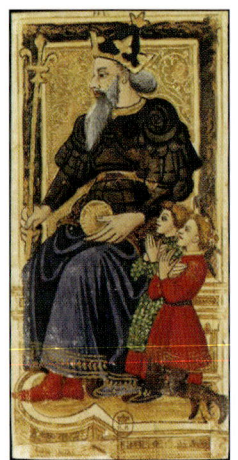

Emperor

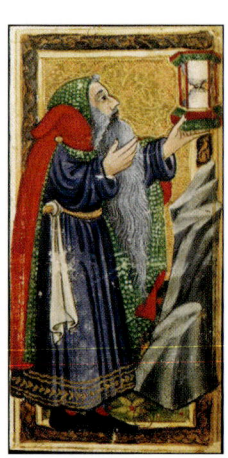

Hermit

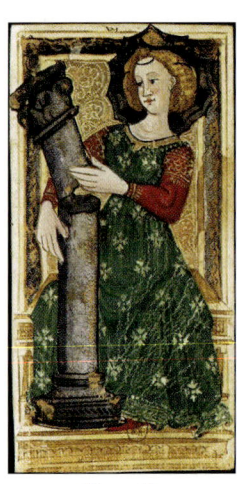

Strength

TAROT DIT DE CHARLES VI: LA MAISON-DIEU

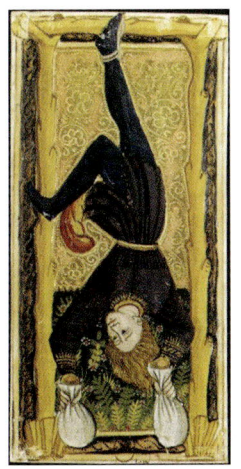

Hanged Man

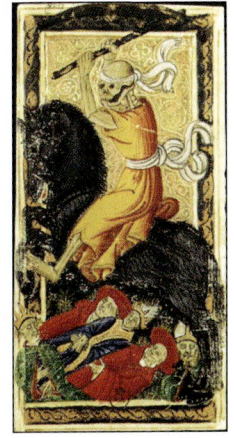

Death

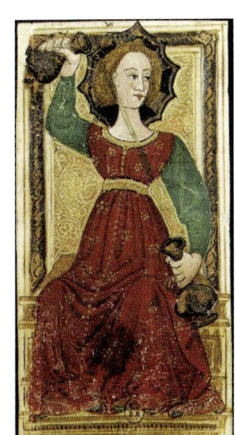

Temperance

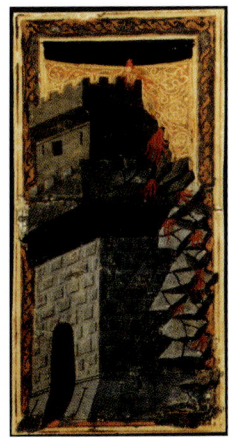

Tower

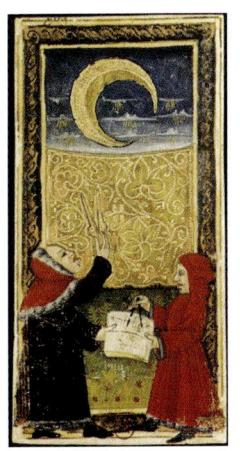

Moon

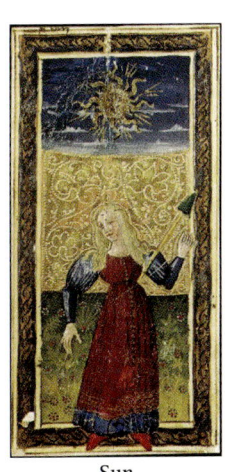

Sun

THE TAROT OF PARIS DECK
17th Century

The original Tarot of Paris (or Paris Tarot) deck was created by an unknown cardmaker. The deck is currently housed in the Bibliothèque Nationale de France (BNF) in Paris. Under the direction of André Dimanche the deck was photoreproduced

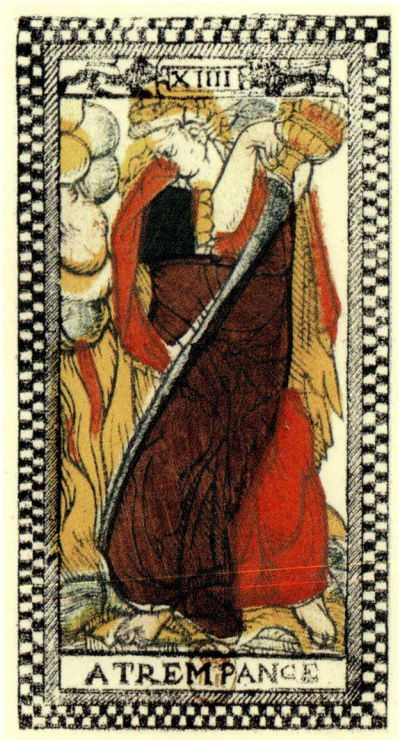
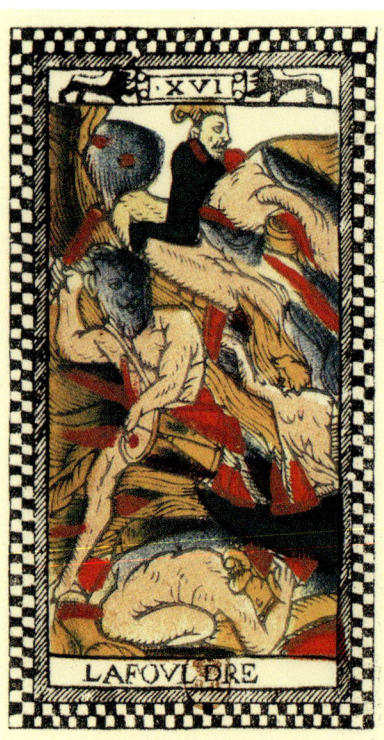

THE TAROT OF PARIS DECK

1984. The stamp of the BNF is on the bottom of each card. The original deck, woodblock printed and stencil colored, may be the oldest complete tarot deck in existence. The checkered border simulates an Italian technique of the era.

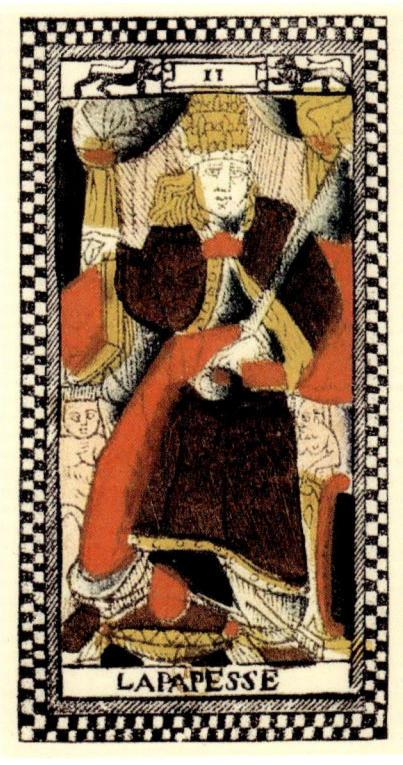
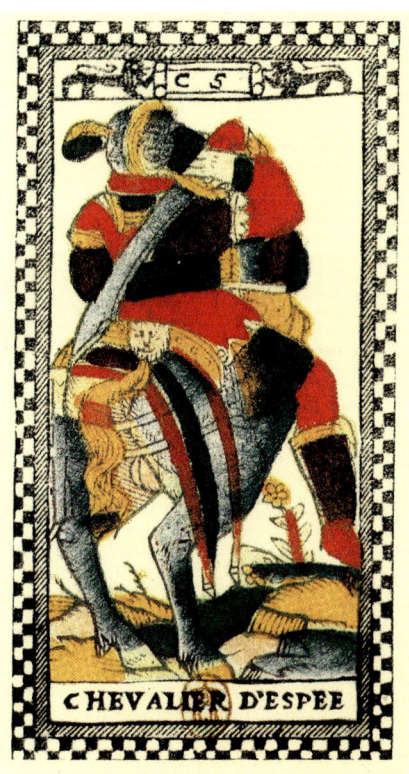

THE TAROT OF MARSEILLES
BY JEAN DODAL

Early 18th Century

The Tarot of Marseilles deck created by the Lyonnaise artist Jean Dodal is housed in the Bibliothèque Nationale de France (National Library of France) in Paris. The deck dates from around 1701. The tarot is believed to have first arrived in France at the turn of the 16th century when France conquered Milan and the Italian Piemonte region. The name Tarot of Marseilles originated much later than this deck was created. One of the earliest uses of the name is attributed to the French occultist Papus in 1889. But not until the 1930s was the name used collectively to refer to a group of closely related designs generated in the city of Marseilles. The 13th (XIII) card, which represents Death, in the oldest versions of the Tarot of Marseilles, and indeed in the Dodal version, is unnamed. La Mort or Death appears in later versions. Today, the Tarot of Marseilles is one of the standards for tarot card design. Many images on the Rider-Waite deck are derivations of those on the Tarot of Marseilles. Many other versions of the design have been made throughout the years and are currently in print. Like the Dodal deck, the Conver deck from 1760 was originally printed from a woodcut and painted by hand or with stencils. Another known deck in the style of the Tarot of Marseilles is that of Noblet from the mid-1600s.

TAROT OF MARSEILLES, DODAL DECK

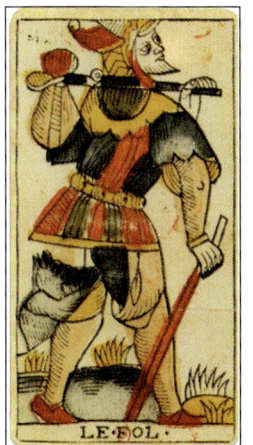
Fool

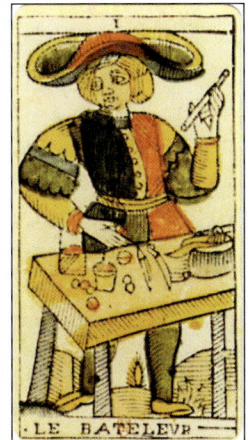
Magician

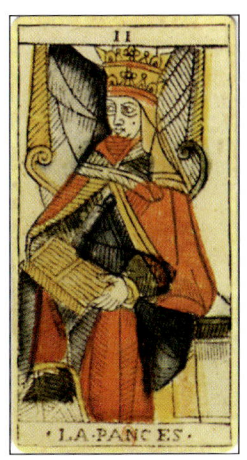
Papess

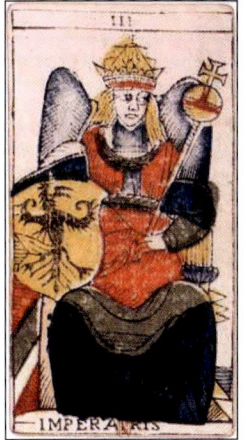
Empress

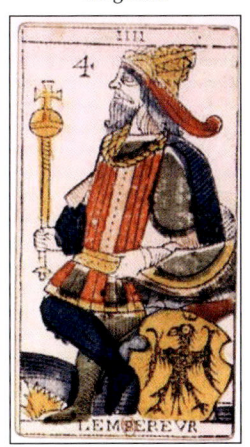
Emperor

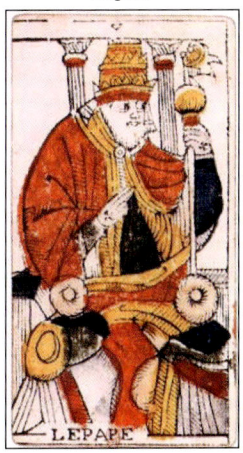
Pope

TAROT OF MARSEILLES, DODAL DECK

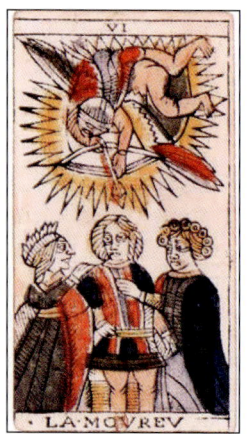

Lovers

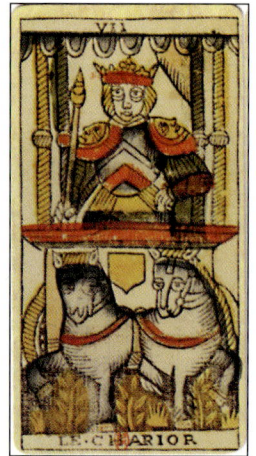

Chariot

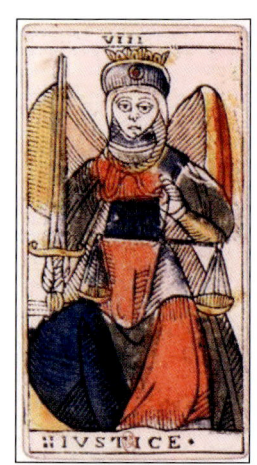

Justice

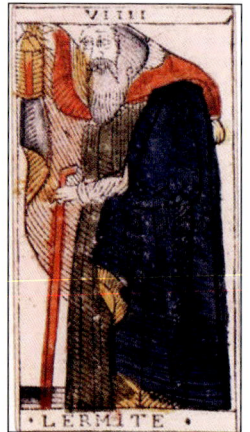

Hermit

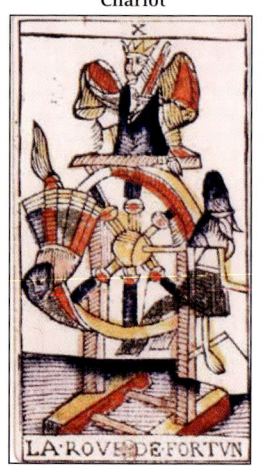

Wheel of Fortune

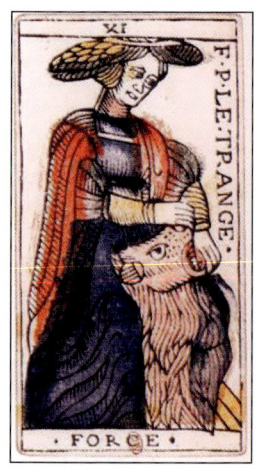

Strength

TAROT OF MARSEILLES, DODAL DECK

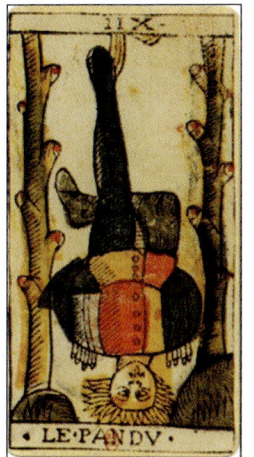
Hanged Man

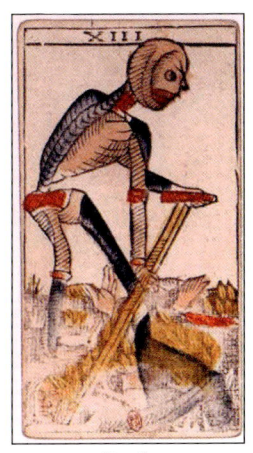
Death

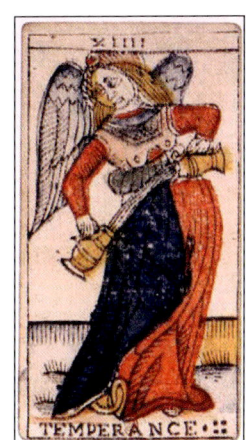
Temperance

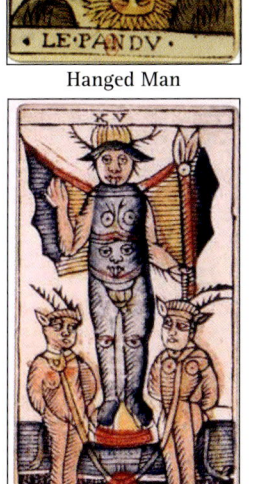
Devil

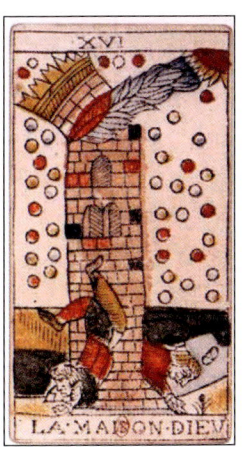
Tower

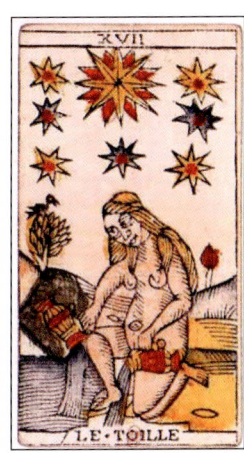
Star

TAROT OF MARSEILLES, DODAL DECK

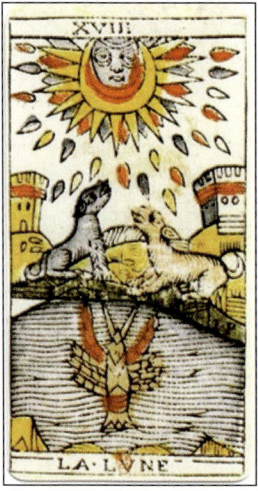 Moon

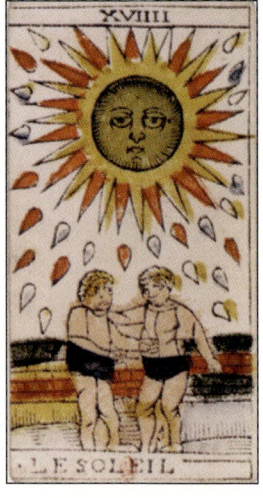 Sun

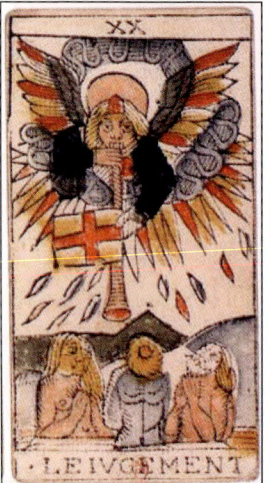 Judgement

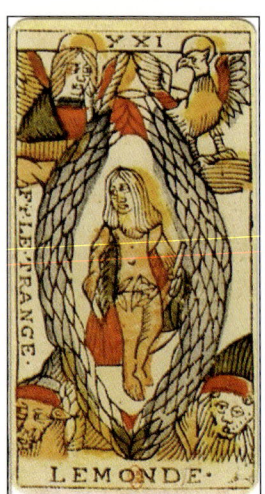 World

TAROT OF MARSEILLES, DODAL DECK

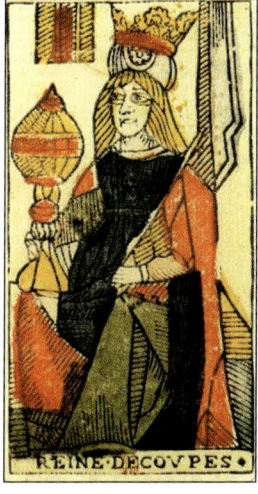

Queen of Cups

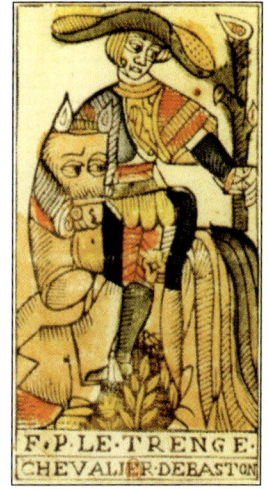

Knight of Batons

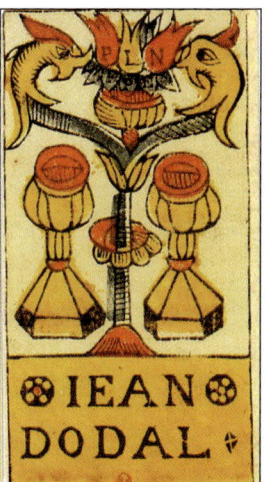

Two of Cups with Dodal's name

Reverse

THE NICHOLAS BODET TAROT DECK
Mid 18th Century

This complete set of tarot cards was created by Nicholas Bodet between 1743 and 1751. The deck is an early example of the Rouen/Brussels Latin-suited tarot and is likely the earliest known deck actually made in Brussels. Each card is a hand-colored woodcut with a black woodcut border.

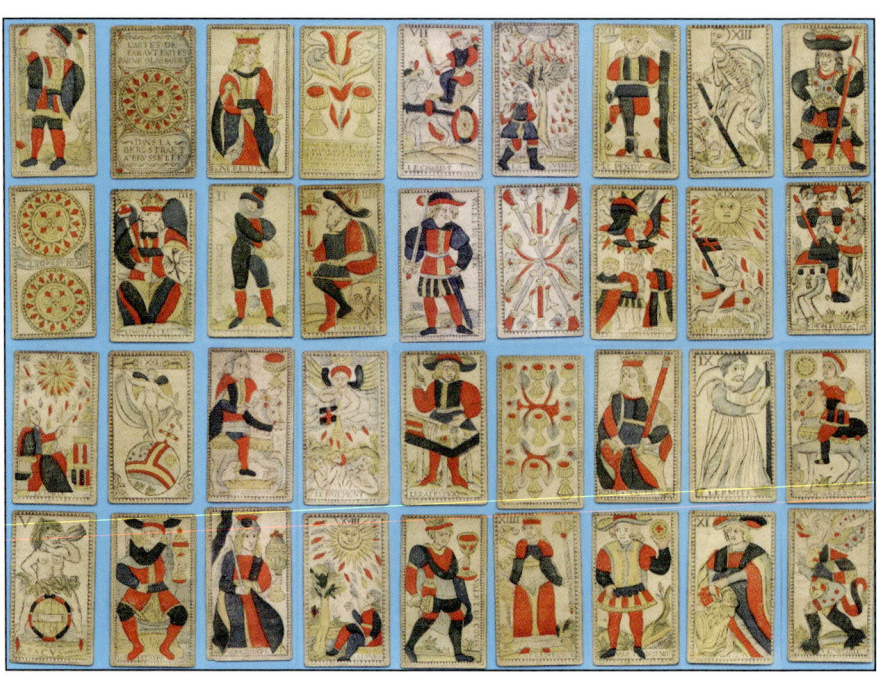

THE NICHOLAS BODET TAROT DECK

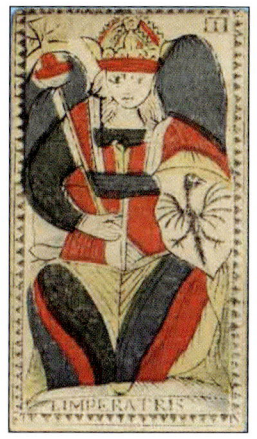
Empress

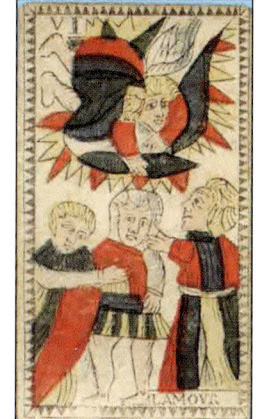
Lovers

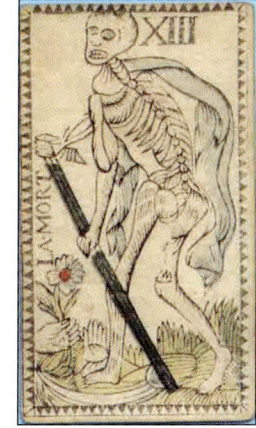
Death

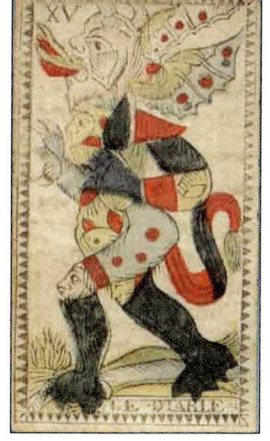
Devil

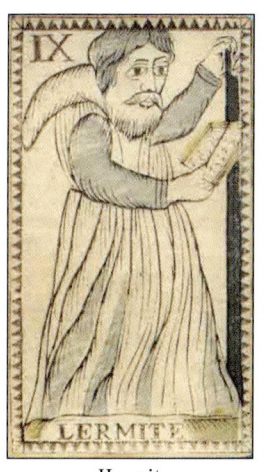
Hermit

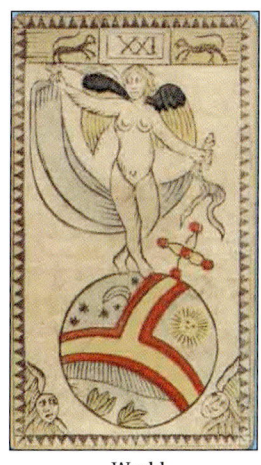
World

THE BESANÇON TAROT DECK
Late 18th Century

The deck at right, a Besançon-style deck, was sold by Christie's in June 2006 for $9,600. It is dated circa 1795 and includes 78 cards, woodblock printed and stencil colored, made for L. Carey of Strasbourg, France. The Besançon tarot first appeared in eastern France, western Germany, and Switzerland when images related to the Church could no longer be included on tarot cards. The typical adaptation was that the Pope and Popess (also called the Papess) were replaced with Jupitor and Juno, respectively. In most respects, Besançon decks replicate the images of the Tarot de Marseilles with some minor changes. For example, the Devil is depicted with furry trousers and torso, and the Moon is in full face. Early examples of the Besançon deck were produced in Constance, Switzerland, circa 1680; Strasbourg, France, in 1746; and Mannheim, Germany, in 1750. Not until the turn of the 19th century, however, were cards in signficant quantity actually made in Besançon, France. A most interesting variant on the typical Besançon design is the removal of all signs of royalty. In 1793, the French National Convention decreed that all royal symbols be removed from the design on playing cards, thus, in the deck shown at right the major arcana cards III, the Empress, and IV, the Emperor, were replaced by La Grand Mere (the Grandmother) and Le Grand Pere (the Grandfather), respectively. In addition, card VIIII, the Hermit, became Le Peauvre (the Beggar). The kings and queens of the minor arcana cards lost their crowns and were called Genie (Knowledge) and Liberté (Freedom), and the valets (jacks) were promoted to Egalité (Equality).

THE BESANÇON TAROT DECK

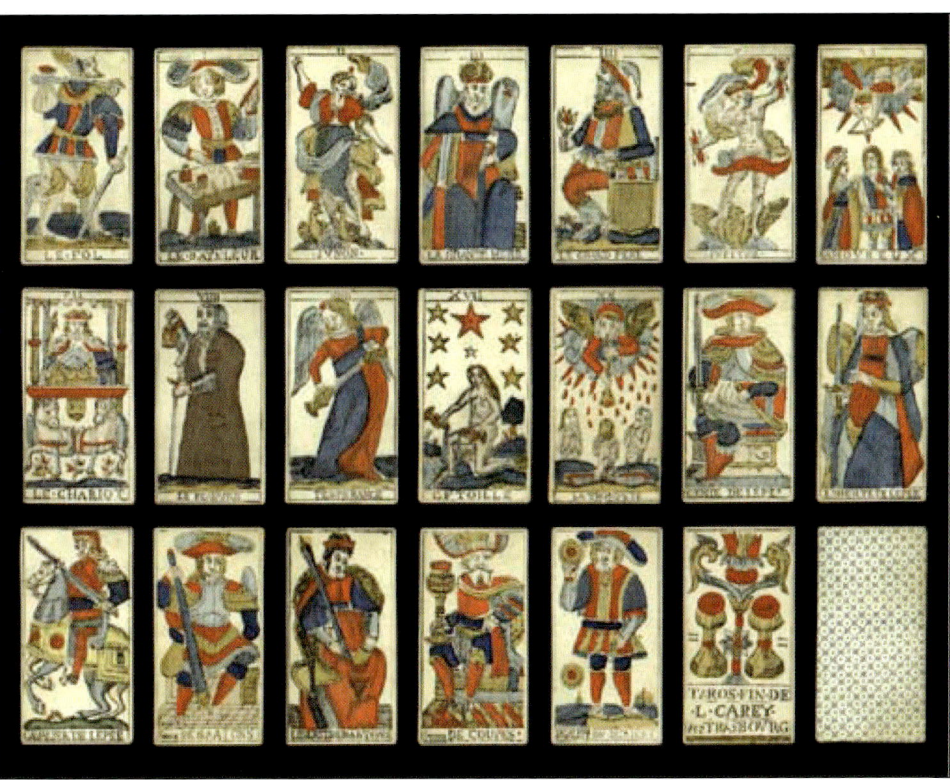

THE GRAND TAROT BELLINE DECK

Edmond Billaudot

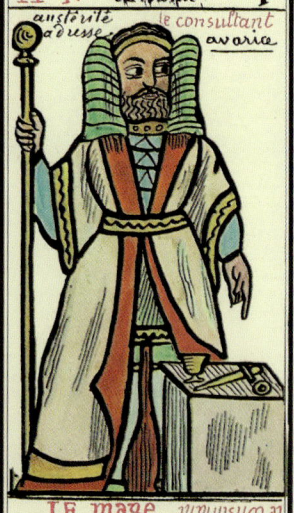

THE GRAND ETTEILLA EGYPTIAN GYPSIES TAROT DECK

Mid 19th Century

THE OSWALD WIRTH DECK
Late 19th Century

Oswald Wirth was a Swiss occultist who lived from 1860 to 1943 in the canton of Bern. He studied esotericism and symbolism with Stanislas de Gauita and in 1889 designed a tarot card deck under his guidance. The deck, however, consists only of the 22 cards in the major arcana. Wirth's designs followed the Tarot of Marseilles, but deviated in certain ways, the most notable being the introduction of occult symbolism. The Oswald Wirth deck is significant in the history of the tarot because it is the first of many following decks to incorporate occult, cartomantic, and initiatory concepts. The deck shown here is an original deck in the hands of a private collector in Japan.

| Fool | Magician | Papess | Empress |

THE OSWALD WIRTH DECK

Emperor	Pope	Lovers
Chariot	Justice	Hermit

THE OSWALD WIRTH DECK

Wheel of Fortune

Strength

Hanged Man

Death

Temperance

Devil

THE OSWALD WIRTH DECK

Tower

Stars

Moon

Sun

Judgement

World

THE THOTH TAROT DECK
Mid 20th Century

The Thoth (or Book of Thoth) tarot is a divinatory deck painted by Lady Frieda Harris and created by Aleister Crowley. The deck was painstakingly created over the five-year period from 1938 to 1943, but was not published until 1969. Crowley's goal was to incorporate symbols from many disciplines in addtion to the occult. He renamed several of the Trump cards: Magician became Magus, High Priestess became Priestess, Strength became Lust, Justice became Adjustment, Wheel of Fortune became Fortune, Temperance became Art, Judgement became Æon, and World became Universe. Each of the cards (or pips) in the minor arcana have titles, with the exception of the Aces in each suit. Each number from 1 to 10 in the minor arcana cards is ruled by one of the sephira on the Tree of Life. The deck shown is in Spanish.

0 Fool

THE THOTH TAROT DECK

I Magus II Priestess III Empress IV Emperor

VIII Adjustment IX Hermit X Fortune XI Lust

THE THOTH TAROT DECK

| V Heirophant | VI Lovers | VII Chariot |

| XII Hanged Man | XIII Death | XIV Art |

44

THE THOTH TAROT DECK

XV Devil XVI Tower XVII Star XVIII Moon

XIX Sun XX Æon XXI Universe

THE THOTH TAROT DECK

Six of Cups Three of Disks Princess of Cups

THE THOTH TAROT DECK

Queen of Cups — Two of Wands — Princess of Wands

THE ALCHEMICAL TAROT DECK

Robert Place and Rosemary Ellen Guiley

THE ARTHURIAN LEGEND TAROT DECK

Anna-Marie Ferguson

THE TAROT ILLUMINATI DECK

Erik C. Dunne

4 of Wands | 6 of Cups | 6 of Swords

THE ANANDA TAROT DECK

Ananda Kurt Pilz

THE DA VINCI ENIGMA TAROT DECK
Caitlin Matthews

The drawings and illustrations of Leonardo da Vinci adorn this deck. The four suits are based on the elements: Fire, Earth, Air, and Water. Da Vinci's sketches have been matched to the tarot archetypes.

THE DIAMOND TAROT DECK

Marie-Louise Bergoint and Klaus Holitzka

THE DRUID CRAFT TAROT DECK

Philip and Stephanie Carr-Gomm

THE DRUID CRAFT TAROT DECK

SIX OF WANDS

0 · THE FOOL

THE ENOCHIAN TAROT DECK

Gerald and Betty Schueler and Sallie Ann Glassman

This 86-card deck is based on the system of Enochian Magic developed in the 16th century by Dr. John Dee and his magical partner, Edward Kelly. The deck was conceived by the Shuelers and painted by Sallie Ann Glassman.

1. LIL	4. PAZ	2. ARN	19. POP	57. AKOA
THE BABE	COSMOS AND CHAOS	BABALON	THE PRIESTESS OF THE SILVER STAR	LESSER ANGELS OF AIR

15. OXO	23. TOR	17. TAN	32. AAETPIO	22. LIN
THE COSMIC DANCE	LABOR	THE BALANCE	FIRST SENIOR OF FIRE	THE VOID

THE GLASTONBURY TAROT DECK

Lisa Tenzin-Dolma

THE GOLDEN TAROT DECK

Kat Black

The Magician	Two of Swords	Queen of Coins	Ace of Cups
Nine of Swords	Two of Cups	Queen of Wands	King of Coins

LE TAROT DES FEMMES EROTIQUES DECK

V The Shaman XVIII The Moon Ten of Wands

THE AFRICAN TAROT DECK

Marina Romito and Denese Palm

The African Tarot, drawn using a primitive art style, is based on the imagery of the African experience. The artist, Romito, reinterprets the standard Rider-Waite images with symbols inspired by South African culture.

THE MERLIN TAROT DECK

R.J. Stewart and Miranda Gray

The Merlin tarot, drawn by Gray, interprets the Merlin legends and Celtic traditions with a strong emphasis on nature and animals. In the major arcana, the Devil is replaced with the Guardian and the goddess Diana is depicted on the Moon card. The cards in the major arcana are numbered differently than in the Rider-Waite deck and the cards in the minor arcana are not illustrated.

I MOON

VI JUDGEMENT

X GUARDIAN

THE MYSTIC DREAMER TAROT DECK

Heidi Dorros

THE NATIVE AMERICAN TAROT DECK
Laura Tuan and Sergio Tisseli

| The Magician | Two of Swords | Queen of Pentacles | Ace of Chalices |

| Father Sky | The Fool | Three of Wands | Knight of Wands |

THE LOVERS PATH TAROT DECK

Kris Waldherr

| PRINCE OF COINS | KING OF CUPS | EIGHT OF COINS |

THE ANCIENT EGYPTIAN SENET TAROT DECK

Douglas A. White and Amy Hsiao

65

THE WILD UNKNOWN TAROT DECK

THE SAKKI SAKKI TAROT DECK

Monicka Clio Sakki

THE CONTEMPLATIVE TAROT DECK
Adriano Buldrini and Giovanni Pelosini

The works of philosopher P.D. Ouspensky influenced the Contemplative tarot decorated with the pagan-inspired artwork of Adriano Buldrini.

THE GOLDEN TAROT OF THE RENAISSANCE DECK

Giordano Berti and Jo Dworkin

This deck is also known as the Estensi tarot because it is based on the 15th-century Charles VI deck, also known as Estensi. Only 17 cards of the original deck remain (see p. 22). The images in this 78-card deck were created in watercolor. The cards are finished with a gold leaf background.

THE CAT-ROT TAROT DECK

Maria van Bruggen

THE RADIANT RIDER-WAITE TAROT DECK

Redrawn and recolored by Virginijus Poshkus

THE RADIANT WISDOM TAROT DECK

Laughing Womyn Ashonosheni

THE SACRED CIRCLE TAROT DECK

Anna Franklin and Paul Mason

THE WIZARDS TAROT DECK

Corrine Kenner and John Blumen

THE WIZARDS TAROT DECK

| Transfiguration | The Dark Lord | The Tower |
| Ace of Swords | Ten of Pentacles | Eight of Wands |

THE WIZARDS TAROT DECK

THE WIZARDS TAROT DECK

THE TAROT OF THE HOLY GRAIL DECK

Stefano Palumbo, Pietro Alligo, and Lorenzo Tesio

THE TAROT OF THE HOLY GRAIL DECK

PENTACLES / OROS	**7**	DENARI / DENIERS

| MÜNZEN | | MUNTEN |

STRENGTH / LA FUERZA	**XI**	LA FORZA / LA FORCE

| DIE STÄRKE | | DE KRACHT |

THE SHIP OF FOOLS TAROT DECK
Brian Williams

Nine of Swords	Three of Coins	X Wheel of Fortune
0 The Vagabond	Ace of Spades	III The Empress

80

THE DEVIANT MOON TAROT DECK

Patrick Valenza

THE SENSUAL WICA TAROT DECK

Nada Mesar and Elisa Poggese

THE SENSUAL WICA TAROT DECK

THE TAROT OF THE CLOISTERS DECK

Michelle Leavitt

VIII Strength

Two of Swords

Queen of Staves

THE HERBAL TAROT DECK

Michael Tierra

THE TAROT OF VAMPYRES DECK

Ian Daniels

THE BASQUE MYTHICAL TAROT DECK

Angel Elvira and Maritxu Erlanz de Güler

THE WILDWOOD TAROT DECK

John Matthews, Mark Ryan, and Will Worthington

6 *The Forest Lovers*

11 *The Woodward*

2 *The Seer*

THE INCIDENTAL TAROT DECK

Holly De Fount

The Oak King	The Alchemist	The Rose Queen
0. THE FOOL	XVI. PHOENIX	XIII. DEATH

THE GHOSTS AND SPIRITS TAROT DECK

Lisa Hunt

13 · Death

King of Swords

19 · The Sun

Knight of Pentacles

Six of Wands

10 · The Wheel of Fortune

THE GHOSTS AND SPIRITS TAROT DECK

THE PAULINA TAROT DECK
Paulina Cassidy

King of Wands · Two of Cups · Queen of Swords

Ace of Pentacles · Eight of Cups · Six of Swords

THE PAULINA TAROT DECK

I ∽ The Magician ∽ Ten of Swords ∽ XVI ∽ The Tower

III ∽ The Empress ∽ Queen of Wands ∽ XIV ∽ Temperance

93

LE TAROT DU CHAT DECK

Carole Sedillot and Claude Trapet

THE FENESTRA TAROT DECK
Chatriya Hemharnvibul

INDEX

African Tarot Deck	60	Native American Tarot Deck	63
Alchemical Tarot Deck	48	Nicholas Bodet Tarot Deck	32
Ananda Tarot Deck	51	Oswald Wirth Deck	38
Ancient Egyptian Senet Tarot Deck	65	Paulina Tarot Deck	92
Arthurian Legend Tarot Deck	49	Pierpont Morgan-Bergamo Deck	16
Basque Mythical Tarot Deck	87	Radiant Rider-Waite Tarot Deck	71
Besançon Tarot Deck	34	Radiant Wisdom Tarot Deck	72
Brera-Brambilla Deck	15	Rider-Waite Tarot Deck	9
Cary-Yale Deck	17	Sacred Circle Tarot Deck	73
Cat-Rot Tarot Deck	70	Sakki Sakki Tarot Deck	67
Contemplative Tarot Deck	68	Sensual Wica Tarot Deck	82
Da Vinci Enigma Tarot Deck	52	Ship of Fools Tarot Deck	80
Deviant Moon Tarot Deck	81	Sola Busca Tarot	20
Diamond Tarot Deck	53	Tarot des Femmes Erotiques Deck	59
Druid Craft Tarot Deck	54	Tarot dit de Charles VI: La Maison-Dieu Deck	22
Enochian Tarot Deck	56	Tarot du Chat Deck	94
Fenestra Tarot Deck	95	Tarot Illuminati Deck	50
Ghosts and Spirits Tarot Deck	90	Tarot of Marseilles by Jean Dodal	26
Glastonbury Tarot Deck	57	Tarot of Paris Deck	24
Golden Tarot Deck	58	Tarot of the Cloisters Deck	84
Golden Tarot of the Renaissance Deck	69	Tarot of the Holy Grail Deck	78
Grand Etteilla Egyptian Gypsies Tarot Deck	37	Tarot of Vampyres Deck	86
Grand Tarot Belline Deck	36	Thoth Tarot Deck	42
Herbal Tarot Deck	85	Visconti Tarot	14
Incidental Tarot Deck	89	Wild Unknown Tarot Deck	66
Lovers Path Tarot Deck	64	Wildwood Tarot Deck	88
Merlin Tarot Deck	61	Wizards Tarot Deck	74
Mystic Dreamer Tarot Deck	62		